© 2020 Spilled Ink and Images

Santina Murin and Katherine Mansfield
Spilled Ink and Images volume i

Published by: Spilled Ink and Images
Layout by: Katherine Mansfield and Santina Murin
Cover Design by: Katherine Mansfield and Santina Murin
A CIP record for this book is available from the Library of
Congress Cataloging-in-Publication Data
ISBN-13: 9781736289006

Distributed by:
Spilled Ink and Images
Pittsburgh, PA
Printed and bound in the United States by Ingram Spark

Spilled Ink and Images
volume i

INK BY SANTINA MURIN
IMAGES BY KATHERINE MANSFIELD

Trigger Warning:

This book contains sensitive content, including mental health, addiction, overdose and death, suicidal ideation, sexual assault, abuse and trauma.

If you or someone you know is struggling with mental health, the National Suicide Prevention Hotline is available 24/7, 365 days per year:
1-800-273-8255

This is for the broken,
the hopeless and the hopeful,
those who keep their heads up,
the ones who keep their eyes down.
This is for anyone who has felt,
feels,
pain, sorrow, anguish, despair,
uncertainty,
for anyone who doesn't know who they are, yet,
and for everyone who knows who they are, now;
for those who are unapologetically me,
for those who embrace their flaws,
strengths and
those who see beauty in the mirror,
be it cracked or whole.
This is for you,
for all.

Misery Loves Company

They say misery loves company,
but I just want to be left alone -
to marinate in my own sadness
the only way I've ever known

Facing myself all on my own,
I'm a hurting heart of ice cold stone
I'll survive this sadness I've come to know
My personal flag of independence flown

They say misery loves company,
but this is just about me
How I overcome myself
and break completely free

The outside world cannot see
what it means to be authentically me
The beaten / broken, the ugly:
what I consider beauty

They say misery loves company,
but I am the misery
and I am my company
That is enough
I am enough

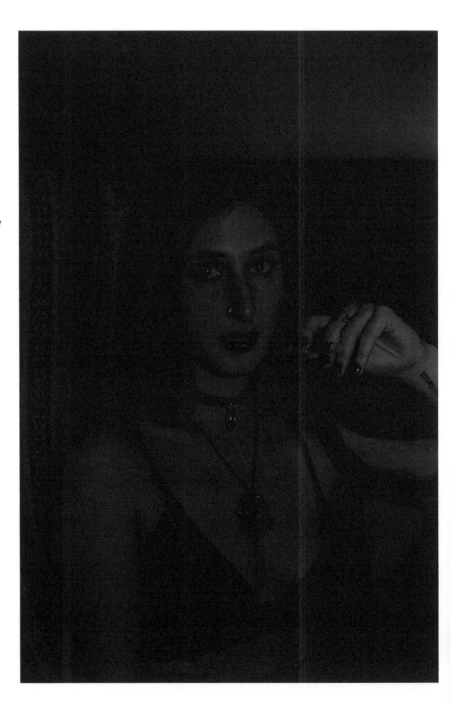

Demons

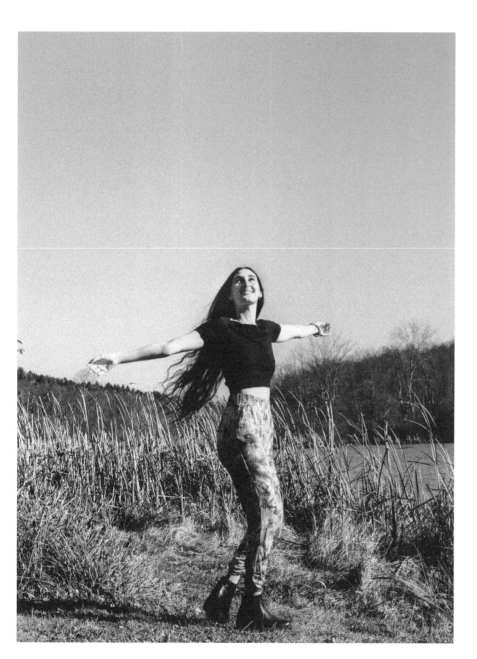

When my demons come out to play
do not try to run away
They need not calmed,
or denied
Do not fear, or try to hide

Connect with them,
intimate as lovers
Two bare souls
underneath the covers

Hand in hand
with dancing tongues,
a love concrete,
beyond young fun

A trick, a treat, a test:
Are you the same
or better than the rest?
Dark, dusty, damaged
habitually pushing away
Forcing an answer:
Will you actually stay?

My Own Skin

My mind sifts through broken thoughts,
a tired heart, searching for an answer
Desperately waiting for you has become
a paralyzing cancer
My tormenting disease, I'm trapped within
So mad,
 scared,
 weak,
I can't bare to live in my own skin
I fall to my knees, and look up above -
My Lord I just want to know, what really is love?
Is it the ground beneath my feet?
 The air that I breathe?
 Those three simple words whispered softly?
I pondered these questions all of the time,
for years; then, realized love cannot be defined
It's a generous glimpse of clarity, we simply know
I released negativity so I can freely let you go
Moving on is rarely easy, no doubt it'll be tough
but, I need to stop feeling like I'm never enough
I'll put my darkness behind me one day at a time
To reach happiness, there's a mountain I must climb
Finally, I'm ready to face the challenge at hand
I'm picking up my broken pieces so I can finally stand
For every moment of weakness will be a test of strength
but, I'm determined to go the entire length
I'm ready to set my heart completely free
I deserve to be happy, and I'm doing it for me

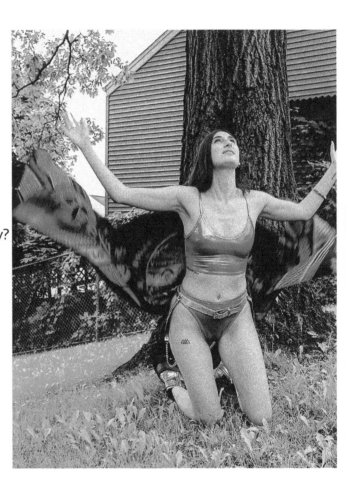

Cry

When the light hits my eyes,
I know I'm alright
Tomorrow I might be fine
But tonight, just let me cry

The silence lingers in my mind,
but no, not the peaceful kind
The deafening, hollowing, intoxicating
realization of being alone:
That's all I've ever known

I'll get through it like I always do
No, I won't forget you,
a new scar which will remain:
The reason for my pain

Tomorrow I will pretend to be fine
But tonight, just let me cry

Manic Behavior

Your words are stained on my brain
and I feel so ashamed
that they're practically framed

You make me feel insane
like I can't be tamed
and must be restrained

I'm putting so much strain -
poison running through my veins
More champagne to obtain

I'm just so drained
from your constant games
causing so much pain

You're an addiction so inhumane
a high to the brain
Absolutely nothing to gain

All I do is complain
that I'm stuck in this lane
but I'm done, logic explained

A lesson not learned in vain
Self love and clarity obtained
Steps to feel sane

Beyond a human hurricane
of fire and rain
A new life to maintain
Happiness and health to entertain

My First Love Story

First love, real love, an adventure filled with bliss
He's someone part of my heart will always miss
For the first time something right, something true
What I'd always searched for, I found in you

We first shared stories and our hearts shortly followed
My self-sabotaging behavior was actually swallowed
A warm, comfortable love, one which felt like home
A pure, gentle reminder I never had to be alone
Intertwined bodies, my innocence lost without regret
A night of love I will never forget

It wasn't "goodbye," it was "see you soon"
Distance means nothing to two hearts in tune
Reality is not a fairytale
Trust runs dry; excitement goes stale
I tried to understand and offered empathy,
but it was clear who would win: his anxiety

To continue on would be to live a lie
I knew in my heart I had to say goodbye
The seasons changed and our lives went on,
but we both knew the love wasn't completely gone

So on with the music! We let our hearts dance
and we gave this love a second chance
Across the country in a house we longed to call home,
but when I moved in I felt nothing but alone

Cold hesitation and resistance, everything had
changed
I knew in my heart it would never be the same
It was time to decide, but what would we choose,
when we both knew there was so much love to lose?

A mutual, respectful, love filled final goodbye
assured me I made the right heart choice to give us a
try
There's such growth in acknowledging the beauty in
pain
and the memories and lessons there were to gain

Last Words

"Can I see you later?"

The last words I sent you
replay over and over in my mind
Bouncing from corner to corner
with no regard for their intrusion
Taking up as much space as
space will allow
Persistent, insistent to stay
Inescapable, like a nightmare
your eyes won't open up from

They linger
and haunt
and stay
A home is made
in the corners of my brain
that refuse to be ignored

You don't realize how
consumingly loud
silence
can be, until it's all
that echos through you
The deafening suffocation has no sympathy
and arrogantly leaves you
as alone as you always feared you'd be

The Beginning of the End

I woke up earlier than usual because I can't seem to sleep without you.
It's colder when I'm here alone.
Not because the seasons are changing and the weather is getting colder,
but because the loneliness is chilling.

My bones ache as they realize life without you will never be the same.
Your infinite love is mine for the taking, but I am stripping your innocence
and stealing this love meant for someone much more deserving than I.

Not because I am undeserving of love,
for no one deserves that version of cruel and unusual punishment,
but because my heart can no longer accept that love
without feeling guilty. Once I understood this,
our always-obvious fate came crashing down —
a dizzying wave, our new reality.

I feel as though I'm supposed to say I'm sorry, but I won't.
I refuse to apologize for taking a chance on our adventure:
one that will burn brightly in my heart until my dying day.
Most people search their entire lives for that. We had it.
I'll forever remember it that way.

We should consider ourselves the lucky ones,
for in my heart of hearts I believe the reward was indeed worth the risk.
Even if I cry myself to sleep for as many nights as I've slept in your arms,
it cannot be triumphant to us. It will not cast a shadow
over a love so bright it can never entirely burn out.

We were a risk to each others hearts from the moment our paths crossed,
and deep down we both knew that.
Despite the truth in our gut, we dove head first
into a pool of unknowns and what ifs.
Even though we are now entering the beginning of the end,
the reward of deeply loving someone who truly loves you back
can never be tainted, even when it's gone.

This is Me

The world thinks it knows her
Happy (an award-winning act)
Pretending, a master of deceit
The world sees her stand on her own two feet

Closed doors, where truth is revealed
A place of isolation in hopes to be healed

Secrets trapped between four walls
Pillows heavy with fallen tears
Sheets unkept with regrets

Fooled by the temptation of the bottom of a bottle
Convinced it's where answers lay
Instead, where they lie

You can't drown pain when it can swim
Amused by how easy it seems to win

Until you decide to overcome, be bigger
Impossible is looking eye to eye with the mirror

Blending both lives, the lines get blurry
Filled with debilitating anxiety and worry

The time has come to call your mind's bluff
To fall from fear, or stand tall and tough

Who is it you really want to be?
The one who hides or the one who breaks free?

Four new walls, where she sets herself free
The day she finally commits to therapy

This is it. This is happy.
This is real. This is me.

X's

X's...
You know the song
that played about an hour long
Over and over, stuck on repeat
Just me, just you, and our heartbeat
Neither said a word, not me, not you
We knew what we were thinking, we didn't have to
Each a safe space for the other to cry
We listened to the song, our soundtrack to goodbye

The lyrics permanently stained
forever engrained in my brain:
> "I don't know what to say
> I don't know what's okay
> But since you've been away
> Been thinking about the mess I made
> Cause you're the X I can't erase"

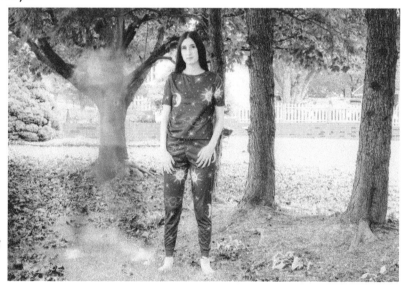

A moment of strength, our tears dried
To make it last forever, we really tried
I didn't want to, but it was time to go
I got up, walked out of that room, sad and slow
Night went and morning came
So did I, but we're not to blame
I'll never forget that final intimate embrace
Because it's true, you're the ex I can't erase

Hallow Goodbyes

Do you feel the void?
Does my absence make a presence?
My anxiety intensifies; silence speaks volumes
You remain composed -
the master of your own heart -
holding any trace of emotion hostage
You refuse to admit what you feel

Maybe I'm just angry you don't actually feel anything
Jealous you can be numb with no effort at all
You drown yourself in booze without fear
of facing who you are, there's no one even there

The empty shell of the person
I promised I wouldn't be is all that's left of me
Mirrors remind me of too much truth
I, too drown myself in booze as if I have nothing to lose
How sobering it is, though, to remember we are not the same

I'll set my emotions free, feel them all intentionally
I even pay to talk about them in therapy
I can look myself in the eye
and appreciate the lessons in
Hallow Goodbyes

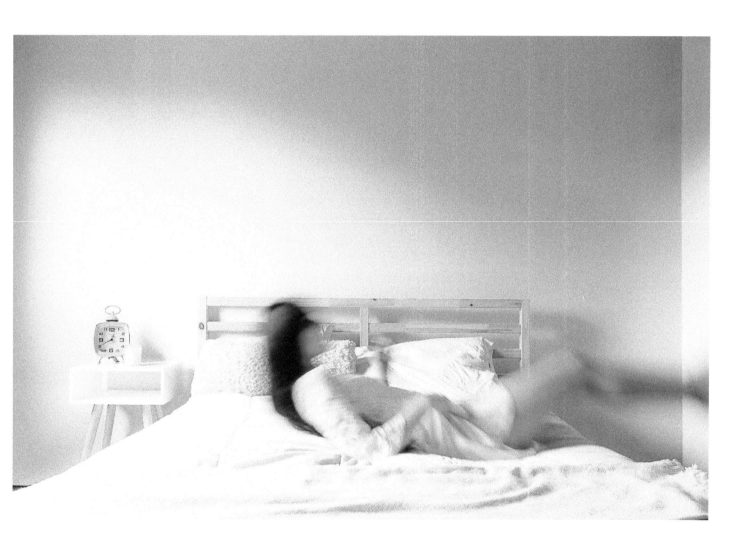

Liquor Lips

I don't drink when I'm sad anymore
Too much to be held accountable for
In my bones I know its counterproductive
and Lord knows I'm already self destructive
So I don't drink when I'm sad anymore

I can't drink when I'm sad anymore
Flashbacks to nights crying on bathroom floors
Makeup streaming down my face
Begging God for a saving Grace
So I don't drink when I'm sad anymore

I won't drink when I'm sad anymore
Reflections of scenes I've seen before
Don't recognize who I see in my own eyes
Like I'm watching a movie of my life's demise
So I don't drink when I'm sad anymore

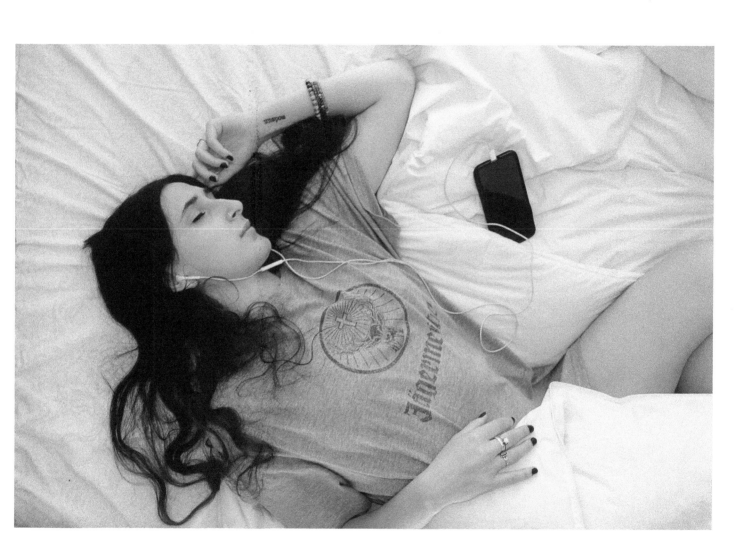

Unapologetically Me

"Unapologetically me"
The words slip from my lips
They taste sour, bitter even
They feel foreign
Like they've been stripped from home
Like they're lost, unaware where to go
Why?
Why don't they taste sweet?
Rolling off my tongue effortlessly?
Why don't they cling to the air
they're released in and flourish?
Instead, they turn cold and dissipate,
losing all recognition of their origin
How do I just be myself?
In a world that begs you to, but beats you
for not doing it the right way, their way
It wasn't until I learned that sour and sweet
pair deliciously,
until I paved my own road toward home,
gave directions to be found,
to find myself,
the one I've been searching for all along,
the one who's been there the whole time,
the one who's here to stay,
to learn, to grow,
to uncover and rediscover,
to finally be free,
to authentically be Unapologetically Me

Words

Words are piercing sharp
and yours penetrate right through the skin,
straight to my heart hiding within
The one that should be beating in sync
with love, not needing to think
The love that simply pours and flows
For you,
For you
Always for you

With each sharp
Twist
Turn
Pull
all that's left
is the feeling of a bloody mess

Nothing left remains
other than blood-tainted stains
On a fragile, shaken soul
broken, unable to stay whole

When pain becomes bearable
and damn near pleasurable,
you must surrender

You're no longer living,
just existing
in your own masochistic mind
Willing to leave logic behind
that fools you, plays tricks:
You're unworthy, can't be fixed
This love is good enough
For me,
For me
Always for me

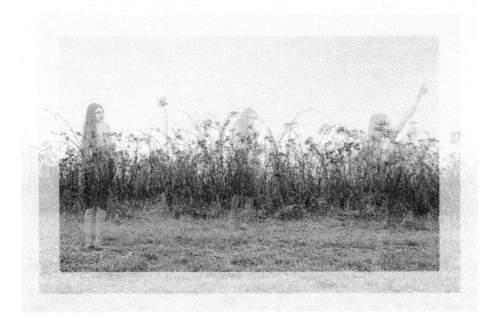

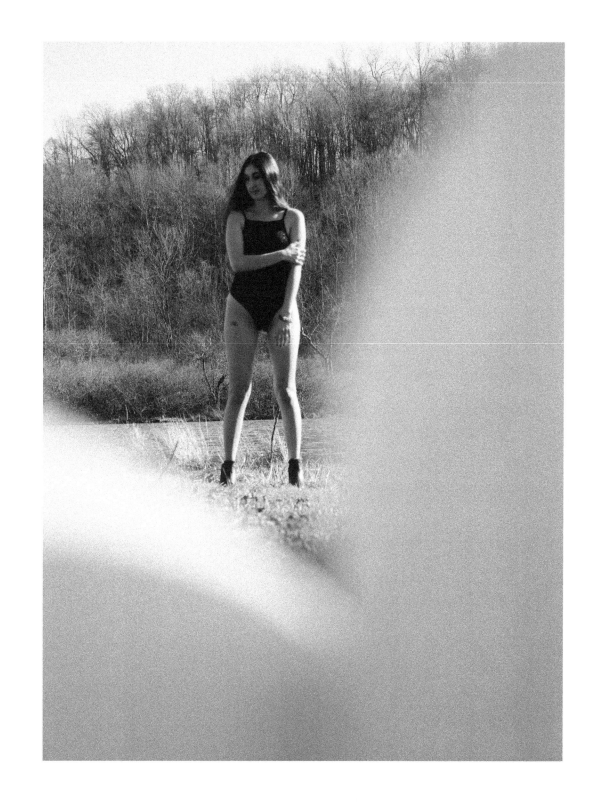

The End

It's worthless to try, it's pointless to care
Nothing really matters, you're still not here

My heart aches; pain is all I feel
My mind refuses to accept this is real

Words won't do justice to the turmoil inside
When two damaged hearts inevitably collide

The air I breathe poisoned with regret
A brutal reminder I'm just here to forget

Can't comprehend your grudge towards me
A typical blame shift unapologetically

Without you, I don't know how to survive
Grasping for reasons to stay alive

I'm drowning in the tears I cry
Flooded by the thoughts "I want to die."

Every word that you spoke was merely a lie
Proving I'm only worth a cold, heartless goodbye

Unwanted, useless, tortured, betrayed
I'd still give you my heart, broken and decayed

The pieces, viciously torn and scattered
Your art is my heart, shiny and shattered

To think, at the start, I was honestly flattered --
Now I see clearly that I never mattered

It's agonizing realizing I can't stand my life
It's like filling my lungs with the blade of a knife

Heavily bleeding on the inside,
Something I can no longer hide

Well, my fake friend, let's not pretend
This is anything other than The End

Your Voice

It just dawned on me:
I don't remember the
sound of your voice

Your words still ring in
my mind like bells on
Christmas, but I can't
recall how they sounded
spilling from your lips

Maybe I was too distracted
by the beauty behind
what you said, or by the
way you tasted to
remember the sound
of your vibrations

Missing the details
isn't usually like me,
especially when I never
wanted to push you to
an abandoned corner
of my mind

Maybe that's why I
don't believe that you
miss me - because I
can't even hear
how you'd say it

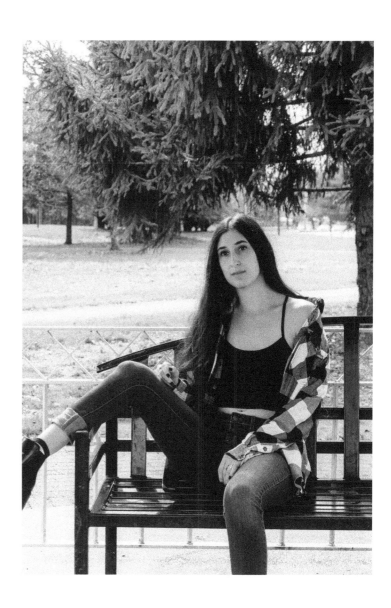

My Truth I Spoke to You

You whispered, "I can't wait to have all of you" and while I knew exactly what you meant, my body, it was a statement I could never shake. Having my body is the furthest thing from having all of me. To have all of me, to explore the boundaries of my intricate mind, to learn the levels of my layered soul, to feel the warmth of my giving heart. You've merely seen glimpses into who I am. You might think you had all of me, but in fact, you've never touched the best parts of me at all.

You told me when it came time for us to go our separate ways, you'd be nothing but a shitty distant memory to me. That's not how I want to remember you or this experience. I fight hard to believe in the good in people and I won't let you spoil that by making me feel like I can't continue to see the best in others. I see through your tough exterior and I empathize with the complexity of who you are, though you're clearly someone I do not know, someone I'm not sure even exists. I wonder if you avoid mirrors because you can't bare to face who stares back at you, demanding recognition.

One of the hardest things in life is forgiving someone who never apologized. Accepting you won't say it only makes me even stronger.

So though you never said the words, "I'm sorry," I forgive you anyway, not because you deserve my forgiveness, but because I deserve the peace. I wonder if I'll ever visit your conscience as a shadow of guilt, or mind as a memory of hope, or heart as a could-have-been if only the universe lined up properly and time was on our side. If and when you think of me, during the remainder of your life, however I come to you, I hope you think of me as kind, bold, and fearless, a woman whose light doesn't dim just because she's covered with the darkness of others.

It's exhausting to feel nothing, to feel something, to feel anything at all, to be numb. The weight of pretending to feel something you don't, of hiding something you do, is far too heavy. It's a burden I'm tired of feeling responsible for carrying. The secrets that live in the corners of my mind forcefully take hold of my thoughts and infect my dreams at night. But it's time for me to break free from these chains and finally get a decent night's sleep. The inner battle is over, I just need some peace.

A Sobering Goodbye

I don't want to lie anymore
because when I lie to myself,
I'm lying to you
and you're the only one
who's ever told me any ounce of truth
I know it's not fair,
but they say life's not fair
that's the one thing
that makes any sense and
how does that make any sense when
we're all just trying to grasp for air
to breathe a little easier
than we did last night
to prove there's any sign of life //
the only person I'm left to fight
is the one within
I said my prayers but
God knows I still sin -
He's quick to forgive -
while we're so quick to judge
the world really could be a better
place with just a little more love
Love, I'll always be with you
but maybe I need to stop ignoring
the music and face the truth
denial is poison and I'm living a lie
quickly approaching a sobering goodbye
broken hearts continue beating
so our minds can begin their healing
with clean air, we can keep on breathing
when we're wide awake or peacefully sleeping
there's beauty in the breakdown
and comfort in the chaos
light still shines at the edge of darkness

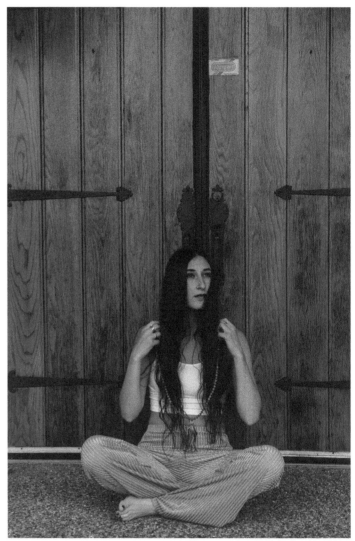

RIP Mac Miller

We lost another precious soul today
Just gone, forever, an unbelievable tragedy
A young life taken, how is this our new reality?

Pain, loss and suffering, you never know what someone is going through
and that smile might just be the cover up to what they're really alluding to
Help me, see me, hear me, I'm trying to show you
I need assistance, guidance, reassurance that I can beat this hell I'm going through

Everyone's so quick to have the answers, pass judgment, voice what they have to say,
but what about the one who will never get to see the light of another day?
No one wants to open dialog, have a real conversation
We're all so desensitized to these fucked up sensations
"Stay away from drugs, just don't do them" as if it's simply that easy
Take a step back and offer up a little empathy
Tensions may be high causing all sorts of friction,
but you don't know how it is if you're not the one battling addiction

Anxiety, depression, serious mental health struggles -
take a hold of your mind, create their own world full of nothing but troubles
You feel like you're weak because you just can't seem to overcome and beat it,
doing your best just to treat it
Getting used to the feeing of feeling nothing at all
It doesn't hurt as much when you can't feel the fall

When you're numb, you don't know when it's too much
"Just a little bit more, this isn't enough"
Until it's too late, and you don't get another chance
to overcome your demons, stand tall, take your stance

You only get one shot at this, one life to live
We need to stop taking, and do better to give
Of ourselves, of our love, of our help, of our heart
If it ends, it's over, we don't get to restart

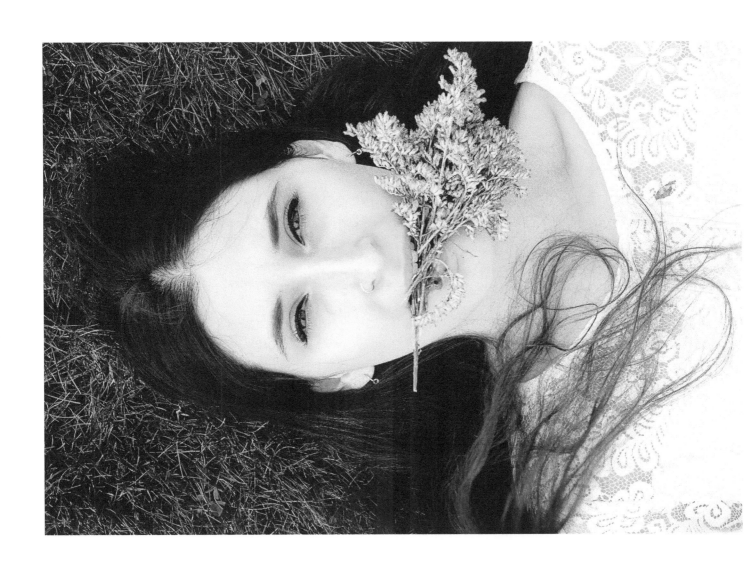

Sadness and Suicide

Never ending, the thoughts racing through her mind:
training for a marathon, going for gold
preparing for the Olympics itself
So focused, they won't slow down;
so determined, won't stop for clarity
or allow room for reality

Mundane household items taunt her,
practically begging to be the Chosen One
The razor she shaves her legs with in the shower winks;
The bottles in her mother's medicine cabinet smile while brushes her teeth
The rope in the corner of the garage grins when she parks her car;
The knife she prepares meals with seduces like an old Hollywood star

Playful whispers turn into threatening demands
"This is it. Take your chance."
"This is the one."
"You want to. Why not now?"
We could hold death in our very hands, if only we so choose to give death life

But when the fear of never really living,
never fully breathing in the better days they preach and promise,
trumps the desire to make a statement by making a wave
in an ocean vaster than you can see,
or surpasses the quest for an answer we likely can't receive -
We recognize the importance of each inhale and exhale,
realize we can yell back,
turn demands back to distant whispers
Comforted by silence rather than terrified of it
Faded chaos,
Distant discomfort,
Scenarios to memories
The will to survive
The need to be alive

One. Twenty One.
Far more than just a number now,
something engrained in my being somehow

It's the time on the clock
my eye seems to always catch

It's the amount of time elapsed
when I look at the song playing

It's the exact length of our video
singing *Beautiful Creatures* at our
last music festival together

It was the ETA for me getting home
the night Illenium's new album came out -

The one I listened to alone
wishing I could pick up the phone
and tell you that I still care,
but I wouldn't ever dare

His previous album,
we listened to together
Back when life felt like
love could last forever

Your number became a part of me,
something I'll treasure unconditionally
A constant reminder that it was real:
gentle pain I'll forever feel

One. Twenty One.
Happy birthday to you
I hope every single wish comes true
I need you to know I still think of you
even if you don't think of me, too

You're someone I can't simply forget
Time spent I'll never regret
Memories treasured, always and forever
Two hearts no longer beating together -

Though you'll always have a place in mine,
one that transcends all space or time
Until my life on Earth is done,
I'll think of you at
One. Twenty One.

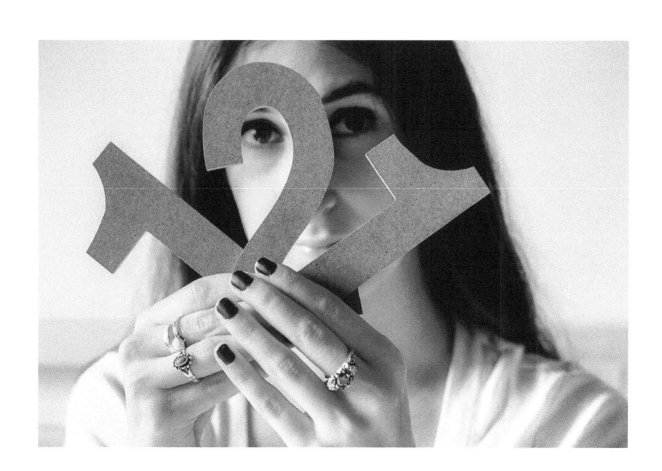

Blurred Lines

No need for a blame game
when we both know how this went down
All you had to offer were lies
for me to soak in and drown

Without hesitation I believed the filth
you spewed from your mouth,
but just when it felt good
is when it all went south

Played like a game:
only want me when you want me,
sitting pretty of a shelf -
You bet I had no self worth,
no respect for myself

I'd lie awake at night wondering
if you might be the exception,
but with your blurred lines
and sheer deception,
there was nothing left to do
but alter my original perception

Suffocating from the silence,
I can barely breathe,
I crash and I burn,
but still struggle to decide
if I should stay or leave

Holding myself hostage
trapped in what was my free-thinking mind,
I know these are crazy, hazy,
unpredictable thoughts that can't be defined

You said one thing
but did another,
I thought we had trust,
some respect for each other

Now there's a constant build up
of - all this - t e n s i o n:
because being married is something
you conveniently forgot to mention

One thing's for sure:
the truth always comes out
I can promise you that
without a shadow of a doubt

What goes around comes around,
we all know Karma
and just how she moves
She has my back now,
I have nothing to prove

You can't drink this away
Memories of me forever burned in your head
You'll live to regret the day
you took another woman to bed

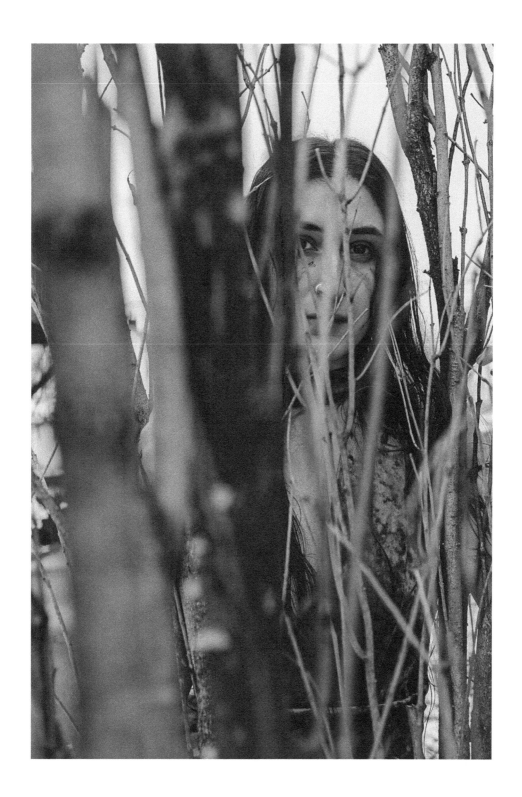

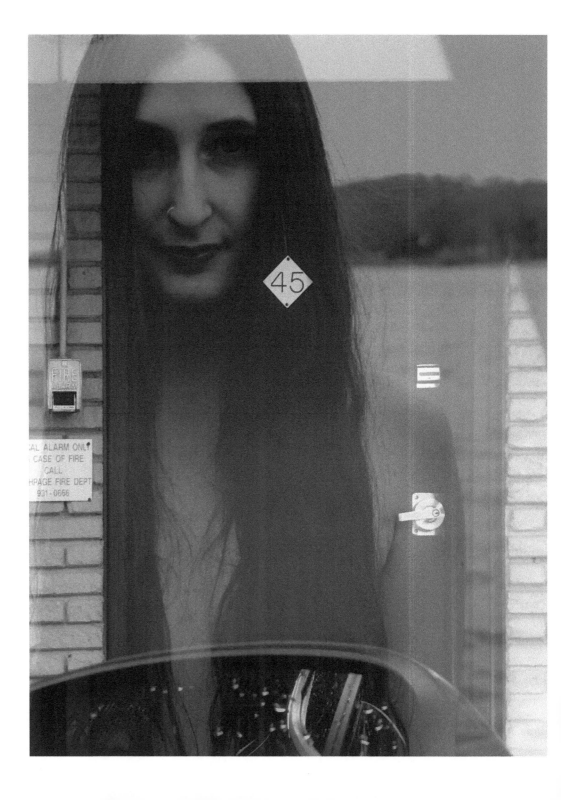

Room 45

A place I thought I could feel safe, open and free
where you could be you and I could be me:
The hotel room where you said to meet
to get tangled up in New York sheets

All the obstacles it took just for us to get there -
You had all that time to be honest or fair
But that night I could not yet know
just three days later the truth would show

How long could you hide it? I was bound to find out
Haven't you heard? The truth always comes out
This is the way you live your life?
Entertaining women who aren't your wife?

Who would know? There was no ring on your finger
No surprise from a heartless sinner
In a church, you took your vows before God
You broke them: as a cheater, liar and fraud

You don't believe in Him anyway
You stood there, said what you had to say
Looking that woman in the eye
To be her husband, and she your bride

The precision of your deception is haunting
Dealing with the chaotic aftermath was daunting
You honestly believed you could keep us all fooled
Such a narcissistic approach to maintain control

A desolate vessel covered in human skin
Suppressed darkness trapped within
Charming lies dancing on your tongue
Nowhere to hide, nowhere to run

There's this guilt I carried from playing a part
in unknowingly breaking your wife's heart
You are who you've always been without my assistance
Now I'm a memory fading in the distance

When you play with fire, you're bound to get burned,
but sometimes such lessons go unlearned
I didn't realize the impact it would have on my life
when I agreed to meet you in Room 45

Coming Out

I'm coming out, but I'm not even gay
There are so many things that I'm dying to say
about life, and the one who made it okay
To be who I am and accept it all:
myself, with a past behind walls
She lifts me up, helps me stand tall
I'm scared and she knows it,
allows me to show it
Hand in hand, no more fears:
Is this what I've been missing
all of these years?

We live in a world that's so God damn cold
I've seen so much shit and I'm only 24 years old
But, for the first time in forever, I feel like myself
She takes all that cold and she damns it to hell

Touched and violated at the age of 14
I did all I could to avoid making a scene
I've carried that pain for years and years
But I refused to shed any heartbreaking tears

And another time, one night out in college,
a night supposed to be filled with such promise
A stranger repeatedly
put his hands on me
I said, "let go."
Why don't men understand the word "no?"
I pleaded: "Don't touch me, just walk away,"
but he made it clear that he planned to stay
I hit him, but he hit me back,
punched me right in the face
In self defense, I was made to feel shame
and entirely expected to absorb the blame

In the end, assault is assault
and it is never, ever, the victims fault
Regardless of what you wear or drink
ignore anything else one might think
"Yes" means yes and "no" means no
and silence, in answer, still means no

When life is good, it is great,
but when it's bad my mind wanders to hate
I fight like hell to battle that feeling
Love is the answer, it's what gives life meaning

I've broken hearts and had mine shattered, too
I foolishly believed the words "I love you."
I've contemplated what it would be like to die
and, oh my God, I have no idea why —

I'm healthy, I'm able,
I'm strong and work hard to stay stable
But I'm young, yet surrounded by so much death
I have good friends who will never take another breath
Overdosing has become such a norm,
I'm hardly surprised to hear they're gone
How sad is that? To not even be phased?
I guess death can happen when you do more than just blaze

We all have our vices; Lord knows I have mine
But through their struggles, addicts still pretend to be fine
Before you know it, there's the call: they are dead
How the fuck am I supposed to clear my own head?

All that I've gone through so far in my life
pushes me harder to do more than survive
I found a girl who understands the real me,
who looks into my twisted soul, wants to set it free

She understands I love who I love without judgements
Although I don't shout it from mountain tops, still
holds no grudges

But from my heart, from me to you:
I love you

We both know it's true at the end of the day
I'm coming out,
but I'm not even gay

Your Ring

I took your ring off my middle finger today
after years of wearing it every single day
A gift from you to me
to replace the gift to me from him

This time I didn't wait for someone new
to replace the gift to me from you
Although one day he might,
and maybe put one on my ring finger, too

At least I'll know I removed yours on my own:
a strength in me I've truly never known
A silent goodbye
to let my heart be free to fly

When my dad gifted me a ring today
I had two choices: it could go one of two ways

He was the first man I've ever loved
It seems only fitting for the ring he gave me
to keep my middle finger warm,
like he tucked me into bed night after night
as I grew up and turned out alright

As I'm all grown up now, I realize it's his ring
I want to wear on my finger
to celebrate myself in the present,
to no longer let my past linger

My heart will hold you every day of my life
but I know you found your future wife
So on a quiet night alone in my room
I gave my new relationship
the permission to freely bloom

In a special place your ring will always be kept,
a precious reminder of the times
I fiercely laughed and painfully wept
Past me never thought I'd see the day
where I'd be able to say
I took your ring off my middle finger today

6:15 AM Phone Call

The moment of truth:
Have you paid attention, studied?
Retained knowledge?
Have you learned the lessons
life was trying to teach you?
That's the thing about the universe:
The same lesson repeats itself
over and over and over until you learn from it
Until you get it,
red flags wave vigorously in plain sight,
you suppress those thoughts and feelings until
you're heeled over with stomach aches and pains
and you hurt too much to walk the talk you publicly proclaim
Can you face the music that rings in your mind?
Symphonies playing the same tune -
Beating to the beat of a heart you can either
let shatter or glue back together
What will you choose?
Yourself? Or borrowed time?
The inevitable will catch up to you
What's meant to be will always find its way and be
Show yourself.
Prove yourself.
Pass the test.
When life calls,
How are you going to answer?

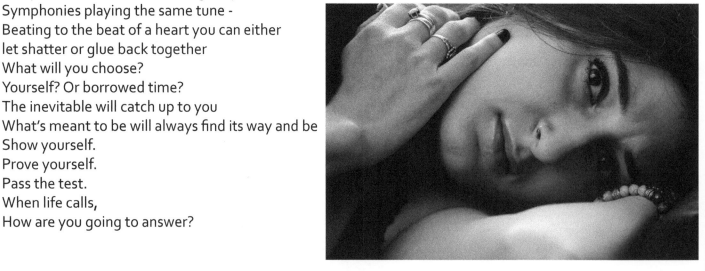

Infected Dreams

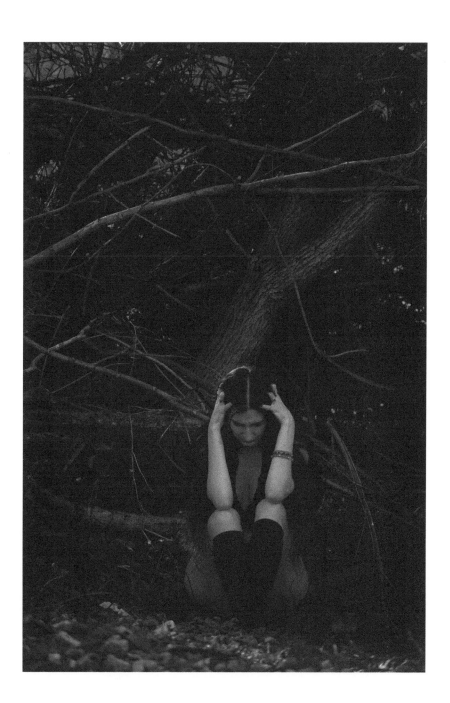

I sleep to escape
But when you infect my dreams
where can I hide?
There's nowhere to go
when you live in my mind

My Light

Why would you want to break me?
Change me?
Rearrange me to estrange me?

You covered me in darkness
like a blanket over a small child
on a cold and quiet winter's night
You allowed your shadows
to consume me
to confuse me
to play tricks on me

I, too, have shadows
and demons who come out to play
to dance among the starry night
There is no light without darkness
Nothing pure comes without pain,
vivid shadows, or shades of grey

I have confronted my demons,
acknowledged their existence
Spoken with them, heart to heart
and healed from them
They grant me peace since we've made nice
with each other

It allows my light to shine brighter,
to burn longer,
to keep me warm when life is cold,
as it far too often is

Yesterday's me would have swallowed your pain
allowed it to consume me, too
I'd take it all on for you
Because isn't that love?
No.
Love doesn't ask someone to burn
when they're taught not to play with fire
My light alone can't save you
Only yours can

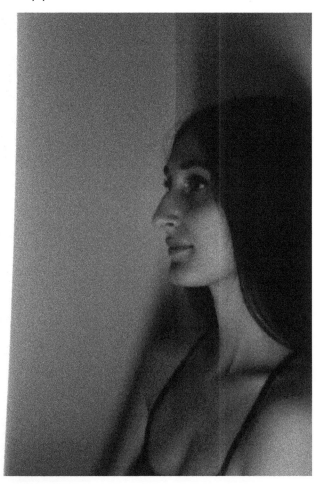

Wasted

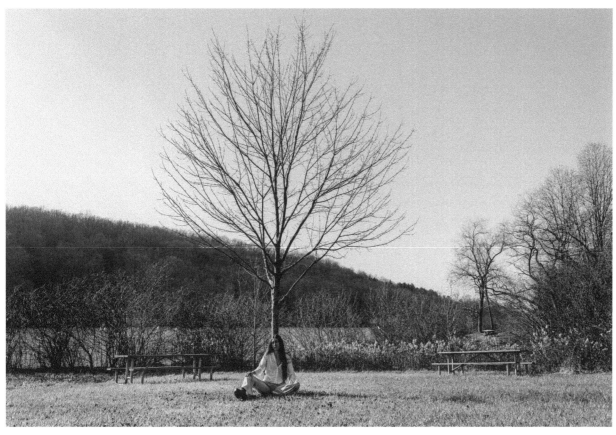

I looked
I touched
I sipped
I tasted
Became tipsy on the thrill your lips gave me

I wanted
I craved
I needed
I stayed
But you left me drunk and my love fully wasted

Time Will Tell

As you sleep next to me so peacefully,
it's hard to imagine all the confusion swarming in your mind
I struggle to comprehend how all that negativity can live there,
but I know it does
I've spent months already pretending it doesn't
Why do we do that? -
 Live in the space where we postpone the inevitable?
 Act like we can't see or feel the truth that's there?
Is it because of
Love?
Devotion?
Hope?
Maybe.
But what's worse?
Breaking my own heart
and the one of the one I love most
in the name of so called strength?
Or fighting to push through
for the possibility of brighter days?
The looming, lingering reality of
The emptiness
The inability to connect
Feelings of not being able to feel at all
might catch up to us after all
Going toe to toe with the unknown
is the only way my heart has ever known
I don't want this love damned to Hell
but I suppose only Time Will Tell

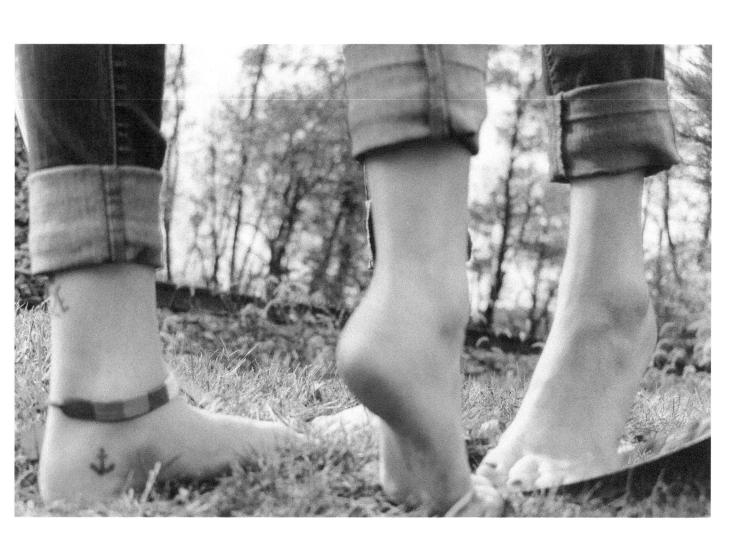

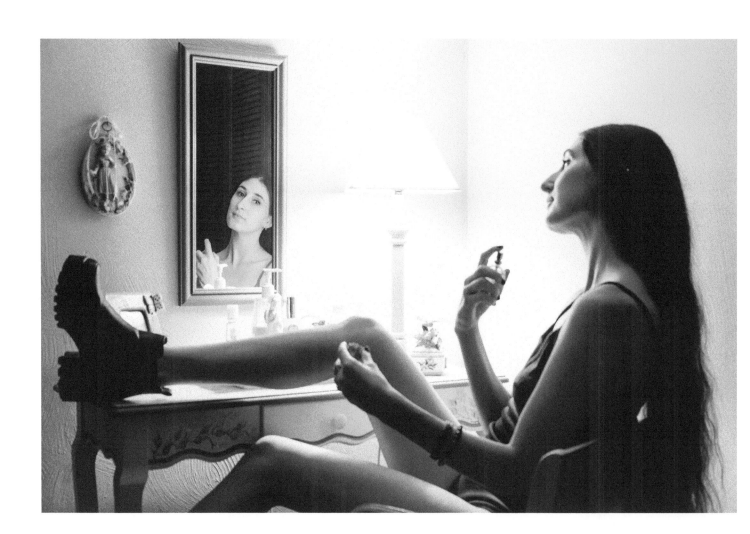

Silhouettes

Our intertwined silhouettes dance
to chaos that echos in my mind
Ringing loudly: this is who I am,
the only way I can ever be defined

Silence and compliance, a lethal combination
My neck, for your hands a constant temptation
I revealed your weaknesses, but you refused to hear
You got your kicks from me hiding in fear

Bend enough and you'll eventually break
Give too much and you're desperate to take
Find myself, strength ignites within
The time is now, a new life I must begin

Won't be constrained, changed, tamed or trained
like a dog in a cage
I'll speak up, scream out
release this fired up heart of rage

I know who I am, a fierce woman with a voice
who finally realized I have a choice
to take my own life into my hands
to fight for myself by taking a stand

Beauty will fade, decompose
Leaving us all nothing but bone
There's more than the surface of skin
An eternity of healing can now begin

You Are My Person

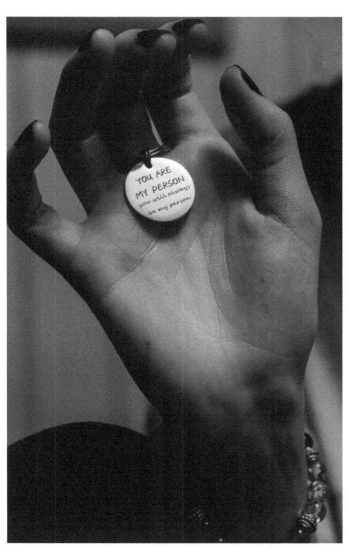

I'm tired of fighting
I just want to be fought for
Why do I always have to be strong
when I need a little more?

Is this a feeling of
inevitable ending in my gut?
Or am I just down
because these times are tough?

Love doesn't ask someone to drown
when they don't know how to swim
So, although I'm undoubtedly hurting,
I choose to stand by him

Life can be such a lonely place
without support and love
So I'm here to remind him
he's not someone to get rid of

I put my trust and faith
to get through in the hands of God
He and I are only human
so of course we're flawed

This isn't the movies;
real life isn't always pretty
A great love story doesn't
just come effortlessly

You are my person no matter
where, what, or when
You will always be my person
now, just as you were then

The Unknown

What is real? What is not?
Mixed emotions and racing thoughts
A mentally lethal combination I'm trapped within,
the way I've got you under my skin

Am I a product of impulsivity?
An outcome to a reaction, chemically?
Unwilling to stay, but refusing to leave
My heart or mind, which to believe?

All we've known is our future's demise
I knew it the moment I looked into your eyes
Windows to a soulless home
You were right next to me, but I was alone

Where we stand now, a hazy limbo
I don't how to both stay and go
My heart will love yours until the end of time
Even if I am not yours, and you are not mine

We can't predict the future, but this much is true:
God brought you to me, and me to you
Our paths were meant to cross
And I believe it's best to love even through fear of loss

Love sometimes turns to pain
But tragic loss leads to lessons gained
We'll walk together, hearts exposed, love shown,
hand in hand into The Unknown

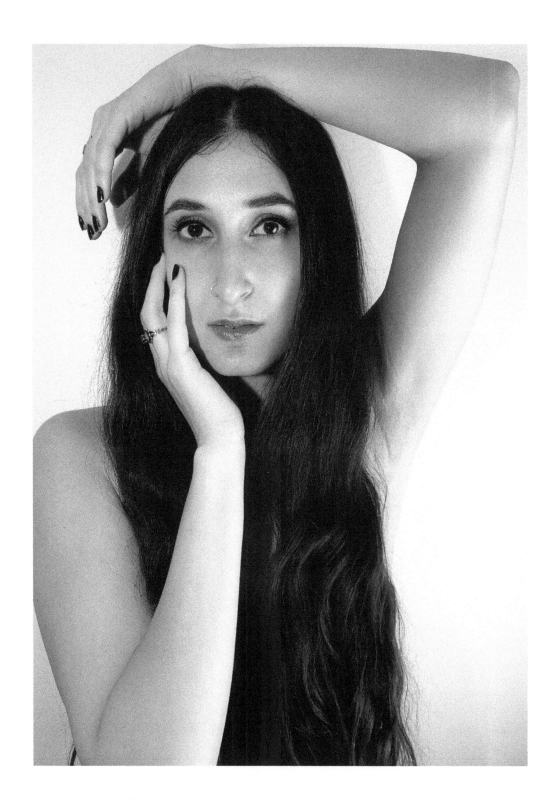

I Am Strong

They say I'm a pretty strong person
so why do I feel weak in the knees?
Why do my bones ache
and my soul shake
when I think of that day?

Those days that blur together
like fog on a long night's drive -
the ones that changed me,
shaped me,
made me, in a way

If seasons change, but we stay the same
what's the point of any of the pain?
If we can't grow from our sorrow
and wait for a kinder tomorrow,
then what are we going to gain?

A middle-school-aged girl
forced to grow up too fast
when innocence was stripped,
allowing only fear to last

Forced to do things
she didn't want to do
by a boy who was probably
a victim of the cycle, too

When I think of it that way
I start to feel sad:
Repeating actions from
experiences he probably had

I have my therapist to thank
for the shift in perspective
She helped me forgive and heal,
to be strong when I'm reflective

My story is still mine, and my
pain is still very real
But with some empathy,
there is allowance to heal

From a child who didn't understand it
to an adult who now does,
I've learned I can do anything
when I face it with love

I, too, now accept
that I Am Strong
and my journey has led
me here, where I belong

Who Am I?

I often ask myself
Who am I?
I've finally come to realize
I wear a disguise
dressed in a million secrets and lies
It's easier to run and hide
when I'm afraid or filled with pride
I may look whole, but I feel broken
Suffering the regret of words never spoken
Smiles on the outside, but do you look within?
Happiness runs deeper than skin
You see laughter as being happy,
but I see happiness laughing at me
So out of reach, unable to grasp
maybe after I take off this mask
No one's ever noticed, so I've kept my walls up
but at what point is enough, enough?
Come too close, I'll push you away
yet I wonder why no one will stay
So, you ask, who am I?
You'll never know if neither do I

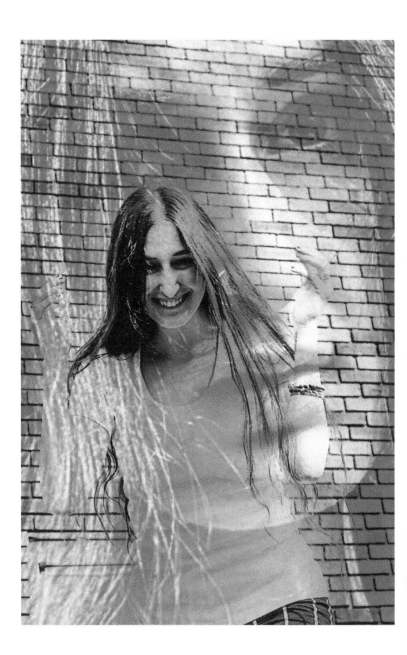

Acknowledgements

Santina would like to dedicate this book to the following:

To my grandma: Thank you for always being my number one fan, for truly always taking an interest in what I have to say, and for being genuinely in awe of anything I've ever shared with you. Our heart to hearts and stories shared, along with so many laughs are things I will forever cherish.

To my mom and dad: Thank you for always supporting me even if you don't always understand my creative expression. The way you both love me is undoubtedly unconditional and that's something I've never had to question. For that, I could never thank either of you enough.

To my best friends: You all know who you are! Thank you for the overflow of confidence, the constant support, and for being the ones I turn to - to cry or laugh with, to vent to, to show my true colors to. Thank you for never judging me, for always keeping my best interest at heart, and for being the ones I trust with my whole heart to tell these real life stories to before they ever became words on a page.

To the ones who have broken my heart: Thank you for the inspiration, for the real pain that turned into art, and for the growth it inevitably led me to. I wonder if any of these pages will ever make their way to any of you.

To the ones whose hearts I've broken: I'm sorry to have ever caused you any pain. If I've ever said I loved you, I meant it. You have a place on these pages, too, just as you'll always have a place in my heart.

To Katherine: Thank you doesn't even begin to cover it. Thank you for being the most incredible creative partner in the world. This has truly been something in the making for years - since we were young girls growing up. Thank you for the being the one to push me into publicly sharing the chaos in my mind, for silencing my doubts every time fear riddled me with anxiety, and for always hyping me up so consistently, no matter what idea I had or what I sent your way for all of these years. We always said we wanted to do this together and look! WE DID IT!

Katherine would like to dedicate this book to the following:

To my parents: Mom and Dad, thank you for always encouraging me to pursue photography and grow in the craft. Dad, thank you for always insisting I take 3,179 photos of dinner before I eat it (ha, ha) and thank you for always asking me questions about my work and offering wisdom. Mom, thank you for giving me the opportunity to take all sorts of wonderful photos, which accompany your excellent journalism. I appreciate your feedback on all my photo shoots. I lucked out in the parent department and words can't express how much I love you both.

Kee: Thank you for always looking over the images I send you and providing thoughtful, constructive criticism. Thank you for helping me grow in my art, and thank you for helping shape me into a better person. Thanks for being the most wonderful, funny, caring, loveable cheerleader-aunt-friend-human being. You make my life bright and I love you.

My siblings: Thanks for sometimes being my subjects and always having my back. Thank you for being my friends and for all of your support. Much thanks for referring me to people you know, thank you for liking my work online, and thank you for taking a genuine interest in my photography. If only I was half as smart, half as pretty, half as badass, and half as successful as each of you. Alas, I just document family events and provide entertainment when Matt needs a breather.

To Josh: Thank you for the hours you give me to create art. Thank you for feeding me, for doing all of the chores so I could sneak some extra minutes of work-time in before we began an evening together. Thank you for looking over my images and thanks for always being supportive and offering feedback. Thanks for loving me.

Zimmy: Thank you for being a (woman's best) friend and an excellent editing buddy.

Santina: Thank you for giving me the gift of artistic collaboration. Thank you for being my muse. For trusting me to create images, for doing the most outrageous things for art's sake, for just being my God, a magnificent goddess. Thank you for your patience with me, your belief in me, your inspiring words, your encouragement, your friendship and love. Thank you for being you, for being in my life. Hell yes we DID!

PS: To Boka because I miss you and if you could see this, I think you wouldn't know 100% what to make of it, but you would be really proud and supportive of Santina and me. :)

About the Author

Santina Murin is a free-spirited, wandering soul who craves all the simple pleasures life has to offer. Her home city of Pittsburgh will always be held extra close to her heart. Poetry allows her to express her heart most authentically.
She's a festival and concert addict, and overall music enthusiast who believes in another life she totally attended Woodstock.

You can find her on Instagram @santinamurin @borntovibe or at www.borntovibe.net

About the Photographer

Katherine Mansfield is a Pittsburgh-area photographer whose favorite things include the first sip of coffee in the morning, the soft glow of a burning candle and watching Mad Men.
When she isn't taking and editing photographs, she enjoys spending time with her family and taking long walks through the city with her partner and their puppy.
She still believes in magic.

You can find her on Instagram @imagesbykatherinemansfield or at www.imagesbykatherinemansfield.com

Ingram Content Group UK Ltd.
Milton Keynes UK
UKHW021702140323
418499UK00004B/182